KKIASRHLIAO
BSLUAGCAK

Karla Black + Kishio Suga
A New Order

**22 October 2016—
19 February 2017**
Admission free
#BlackandSuga

←

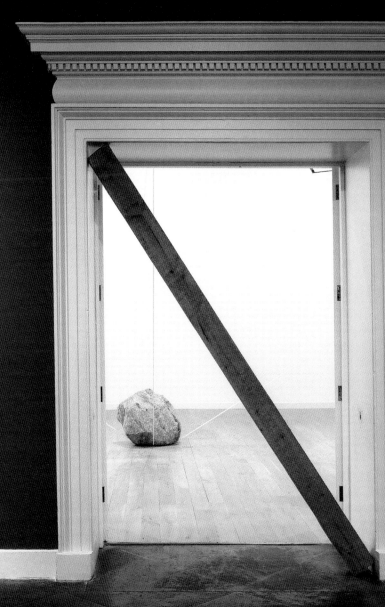

KARLA BLACK + KISHIO SUGA

National Galleries of Scotland

A NEW ORDER

Edinburgh 2016–2017

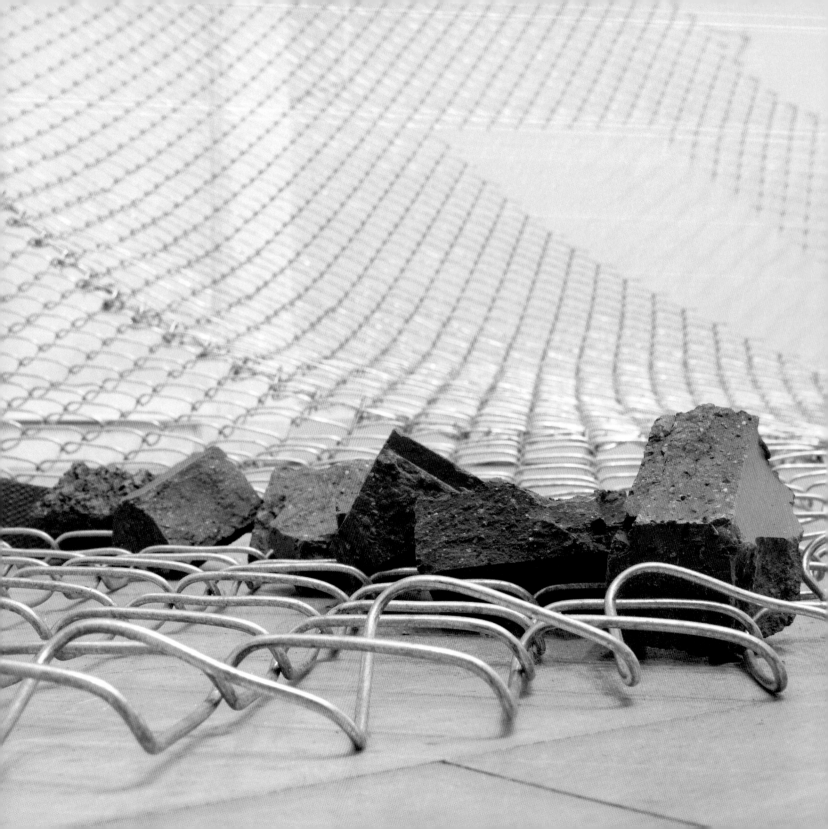

DIRECTORS' FOREWORD

Karla Black and Kishio Suga: A New Order is an exhibition conceived by the Scottish National Gallery of Modern Art that brings together for the first time the work of artists Karla Black (b.1972, Alexandria, Scotland) and Kishio Suga (b.1944, Morioka, Japan). Unaware of each other's work before this show, what unites the two is their use of everyday materials – many of which are not commonly associated with art-making – to create works of beauty and complexity, in response to specific spaces and locations.

Karla Black makes abstract sculptures with traditional art supplies such as plaster, paint, paper and chalk, in combination with everyday items including soap, eyeshadow, petroleum jelly, toothpaste and lip gloss. Although many of these materials may serve as a reminder of the intimate, daily acts that are commonly associated with women, such as applying make-up, Black does not select them for this reason. Her concern is with the physical properties of matter – texture, colour and feel – rather than their cultural associations.

For *A New Order* Black is presenting new sculptures, most of which – because of the scale and materials involved – she made directly within the rooms of the Gallery. The exceptions to this are the series of hanging sculptures made from cotton wool, as well as *Actually Mark* and *Of End*, which were produced in the artist's studio in Glasgow.

Kishio Suga also uses everyday materials, including rocks, pieces of wood, wire, rope, metal – in fact, almost anything to hand – to create what he calls 'situations'. Bringing materials together, often in apparently random combinations and configurations, Suga aims to highlight their physical qualities, their interdependent relationships and their connections with the surrounding environment. As Suga has written here, 'an artwork is a product of abandoning preconditions and organising new orders ... I make artworks so that people can see and learn about *things*, so they can perceive an existing space differently and thereby experience a new kind of order. If they can apply their experience with art into their daily lives, the new order may find settlement there.'

In addition to a new work conceived specifically for the exhibition, *Interconnected Spaces*, Suga is represented by a selection of re-created room-sized installations, photographs and videos of his performance works, spanning his nearly fifty-year career. All of the materials in the exhibition were sourced locally and Suga's works were assembled by the team at the Gallery, following instructions from the artist.

We are deeply indebted to the great energy, vision and commitment of the artists. We are grateful to Susie Simmons and Ronnie Black, who helped install Black's works, and to the support given by her galleries, in particular Dorothee Sorge at Gisela Capitain, Stuart Shave and David Zwirner. We would like to thank Blum & Poe, and in particular Ashley Rawlings for his great knowledge and help with installing Suga's works. At the Gallery, we would like to thank Cassia Pennington, Cai Conduct, Gillian Achurch, Claire Walsh and especially curator Julie-Ann Delaney. Finally, we would like to thank the Japan Foundation, and are indebted to Walter Scott & Partners Limited for their inspirational and steadfast support enabling the Gallery to stage such original, and striking, exhibitions.

SIR JOHN LEIGHTON
Director-General, National Galleries of Scotland

DR SIMON GROOM
Director, Scottish National Gallery of Modern Art

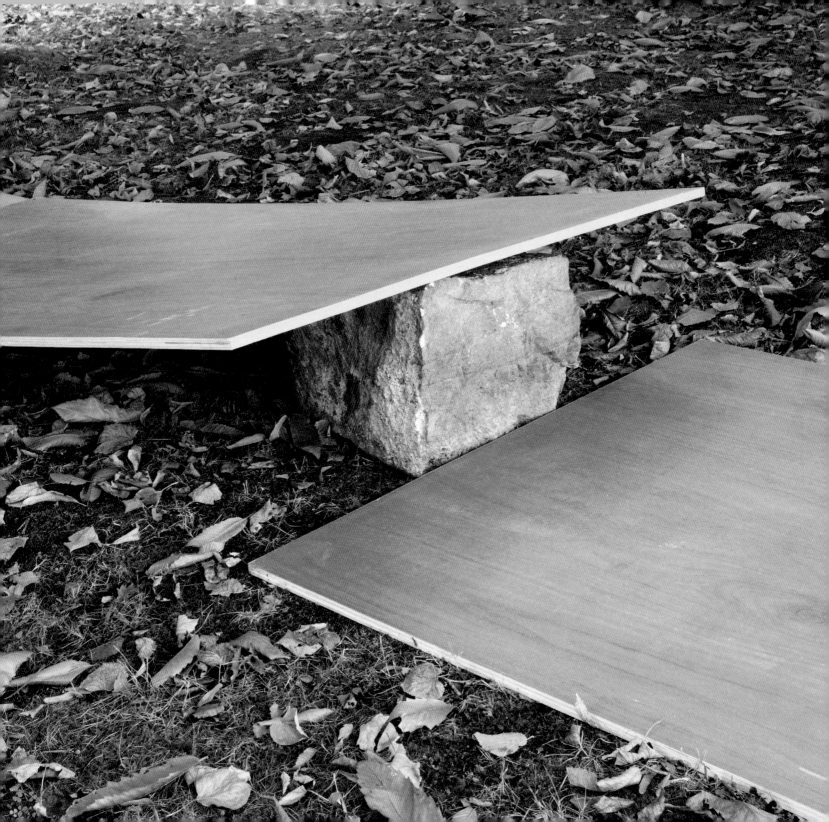

BETWEEN 'PRESENCE' AND 'NOTHINGNESS' (2005)

Kishio Suga

When I make my work, regardless of whether I like it or not, I think about the notion of 'order'. When one starts combining things to make a surface or a sculpture, simply having all the materials ready and knowing how to express something with them does not necessarily mean that the end result will be a colourful painted surface or an astute object. While I might have a certain concept or creative intention in mind, usually I contemplate what is before me in silence.

As I begin, I look at the materials and then I look for a space of 'nothingness' in which to ground them. This allows me to sense a kind of order that is inherent to those materials and the space. Perhaps that order is necessary for the artwork, and it derives from the places the materials belonged to before I gathered them together. All things and all spaces belong to a particular world of their own before someone picks them up, and in those worlds they all have an order assigned to them by nature or people. In this case, 'order' is a hierarchical condition – a categorisation in terms of their role, value, desirability, quality or quantity. One can say that the things or spatialities that have been amassed from a certain site exhibit the nuances and traits of that site. This is the order one senses when faced with the elements of existence.

For people who make things, it is important to know how to handle this experience – how to eliminate preconceptions and functionalities. This is the first thing an artist must do, because an artwork should stand outside of any preconditioned order. Otherwise it will not have the capacity to contain the full spectrum of concepts the artist wishes to introduce. The artist's concepts are an order in their own right.

In that sense, making an artwork is about applying orders to things and an artwork is a product of abandoning preconditions and organising new orders. To do this, artists have to maintain absolute concentration when considering materials and spaces.

When artists are in that state, their perception of things and spaces empty out into nothingness and just exist there in the mind. In my view, this state of being is akin to chaos.

While the artist's perception of things and spaces is completely empty, at the same time it maintains just enough sense of existence, and the artist must consider what kind of order could transform this sense of existence. This process is much more difficult than it sounds. Our perceptions and values are shaped by the places we grew up and the people who were around us; our thoughts are tied to these standards, and there is nothing simple about deconstructing preconditioned orders. The creator of an artwork can easily get caught up in it, and in those situations one must not expect much of the result. Viewers who continue to rely on preconditioned orders might be satisfied with such an artwork, but those who think about new orders will likely be uninspired.

This issue is not limited to viewers alone. There are artists who still base their standards on mundane orders such as harmony, balance and rhythm.

It is crucial to keep searching for new orders of existence without fearing the destruction of old ones.

I constantly think about how to confuse or distort the typical order of things. This is akin to inserting an unfamiliar or incomprehensible word or sign into the middle of an otherwise ordinary sentence. Viewers would be rendered

speechless before an artwork of this kind. In a matter of seconds or minutes, their thoughts would shift from established orders to new ones. Some viewers would complete the shift while others would not.

In most cases I use elements and structures that transform the order of the artworks I make. Sometimes I think about how to introduce a completely different order that would stimulate the viewer's ways of looking and thinking about things to the point where they perceive another world altogether. In these cases, there is no need to use materials and spaces with strange shapes or anything extreme about them. I give the work a typical appearance but add some external elements. It is like altering a key so that it no longer fits the keyhole. At the same time, I also make works in which the order is clearly distorted.

In any case, I make artworks so that people can see and learn about *things*, so they can perceive an existing space differently and thereby experience a new kind of order. If they can apply their experience with art into their daily lives, the new order may find settlement there. There would be no turning back. I want to induce new ways of responding to situations in all viewers.

Kishio Suga **Space-Order**, 1974
界律 (Kairitsu), 1974

This essay was first published in *Kishio Suga's Work from a Zen Perspective* (Itamuro: Kishio Suga Souko Museum, 2008). It was originally translated by Naoto Katou and Ashley Rawlings, and titled 'Between "Existence" and "Nothingness"'. Ashley Rawlings has revised the translation for its publication in this catalogue.

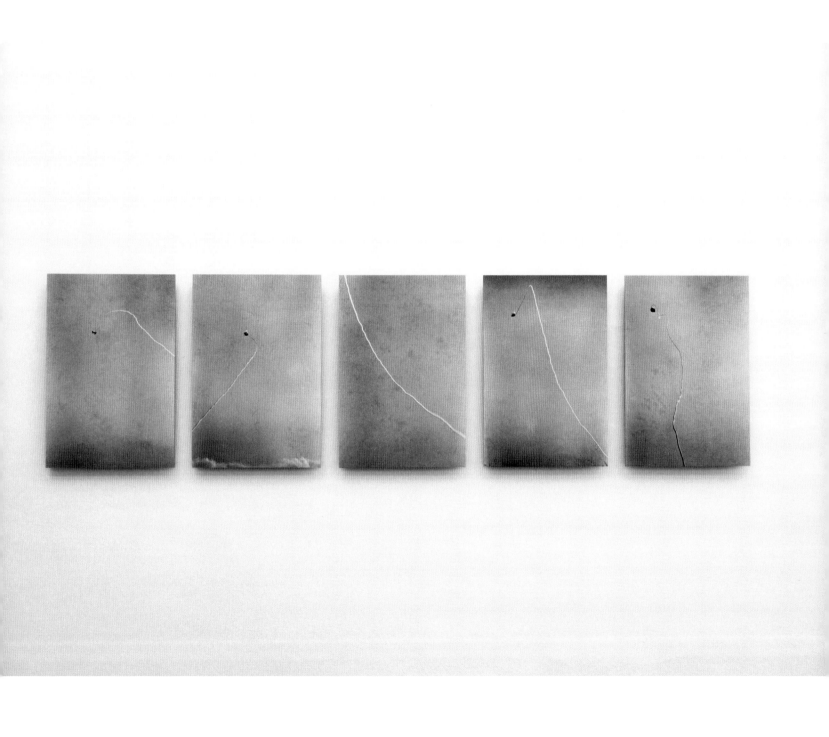

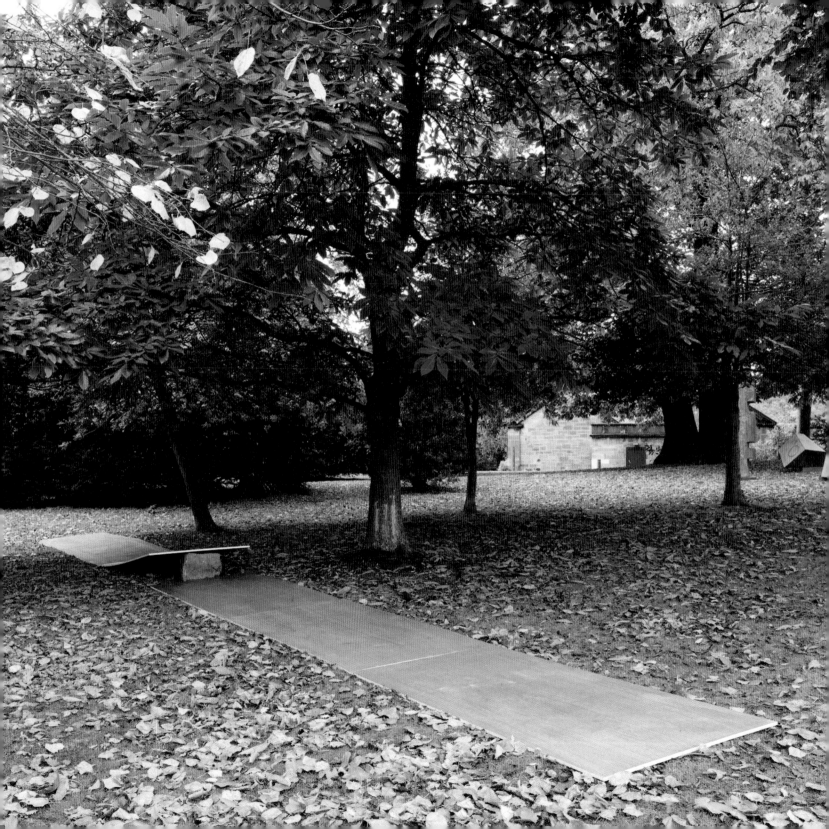

Kishio Suga

Determined Condition,

Discrepant Placement,

1969 / 2016

定状差置 (Teijō Sachi),

1969 / 2016

Kishio Suga

Infinite Situation I (Window),

1970 / 2016

無限状況 I (窓) (Mugen Jōkyō I
(mado)), 1970 / 2016

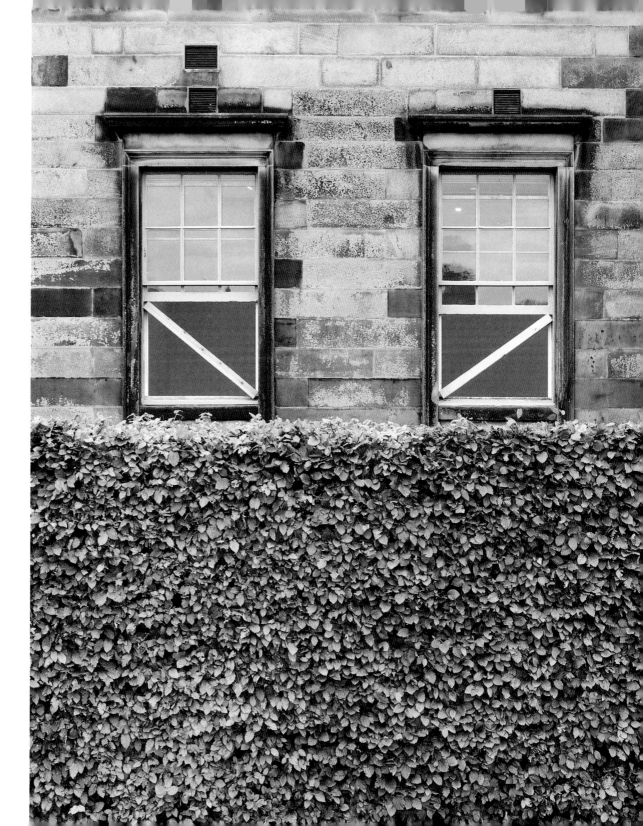

Kishio Suga **Inactive Environment**, 1970
無為状況 (Mui Jōkyō), 1970

Kishio Suga **Branched Condition**, 1973
枝況 (Shikyō), 1973

Kishio Suga **Elemental Realm**, 1974
素界 (Sokai), 1974

Kishio Suga **Remaining Locating**, 1975
留位地 (Ryūichi), 1975

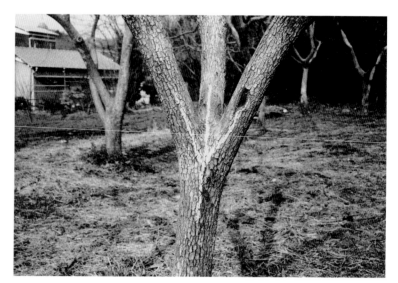

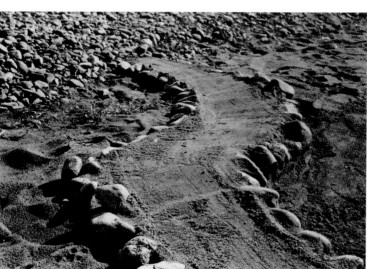

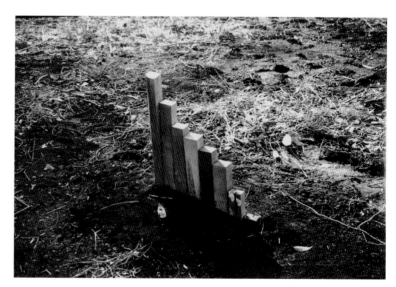

Kishio Suga **Connection,** 1973
弦 (Gen), 1973

Kishio Suga **Floating Units of Perception,** 1973
水上識体 (Suijō Shikitai), 1973

Kishio Suga **Remaining Space,** 1975
間留 (Kanryū), 1975

Kishio Suga **Natural Order,** 1975
自然律 (Shizenritsu), 1975

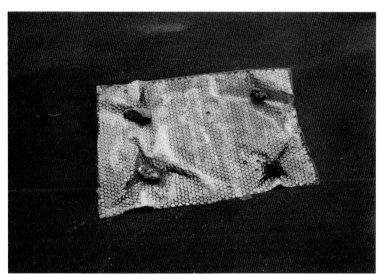

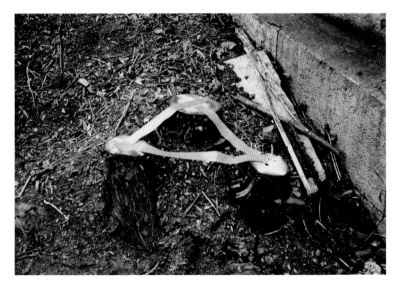

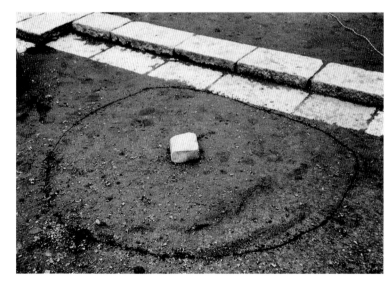

Kishio Suga **Edges of Gathered Realms,** 1993 / 2016
端の集界 (Tan no Shūkai), 1993 / 2016
[detail; installation view]

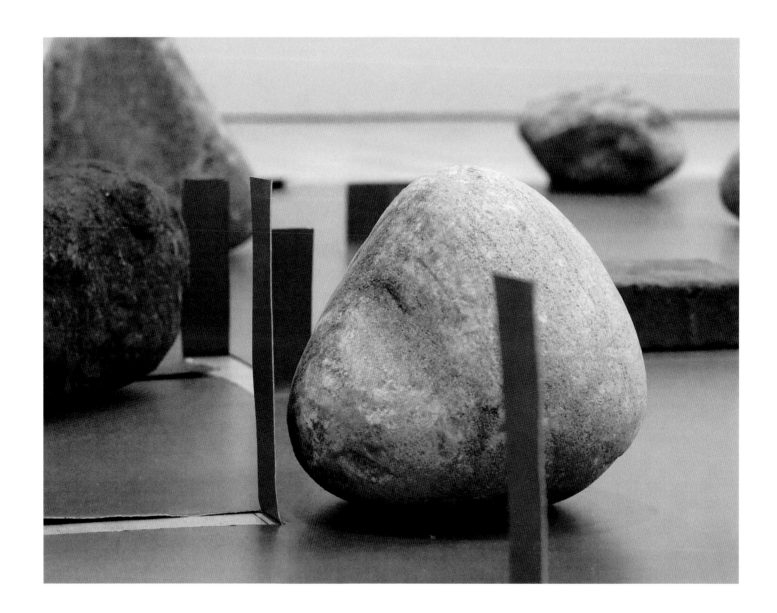

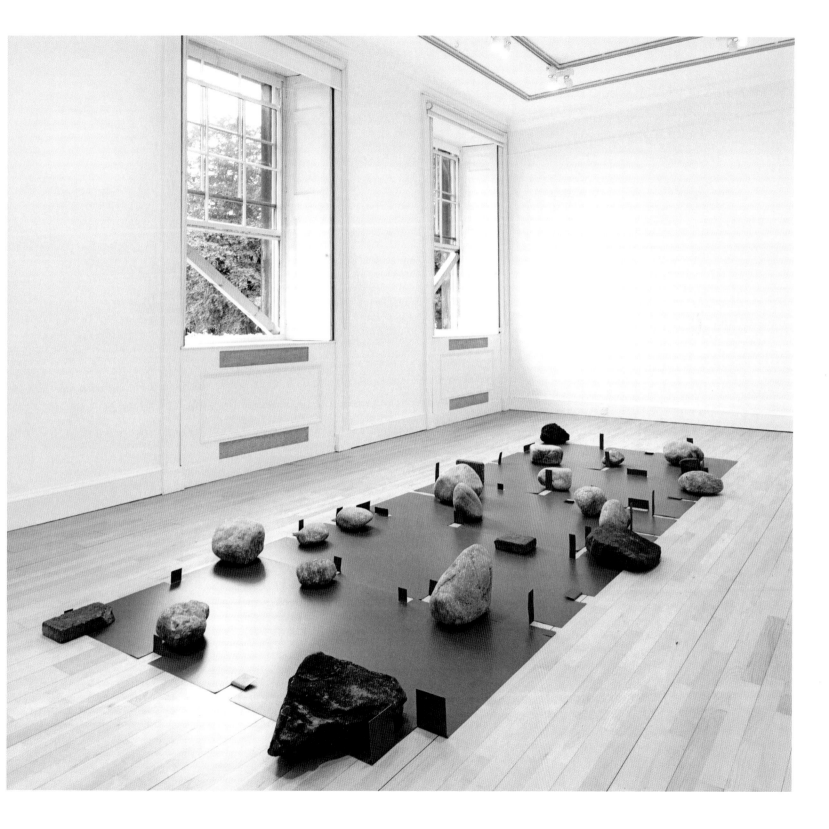

Kishio Suga Left-Behind Situation,
1972 / 2016
捨置状況 (Shachi Jōkyō), 1972 / 2016

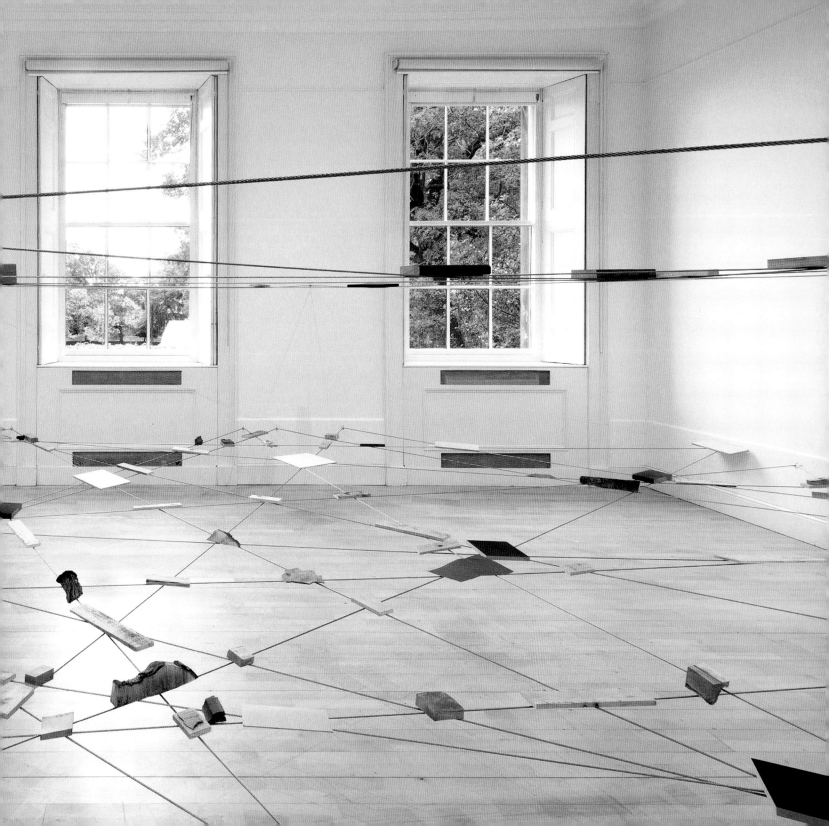

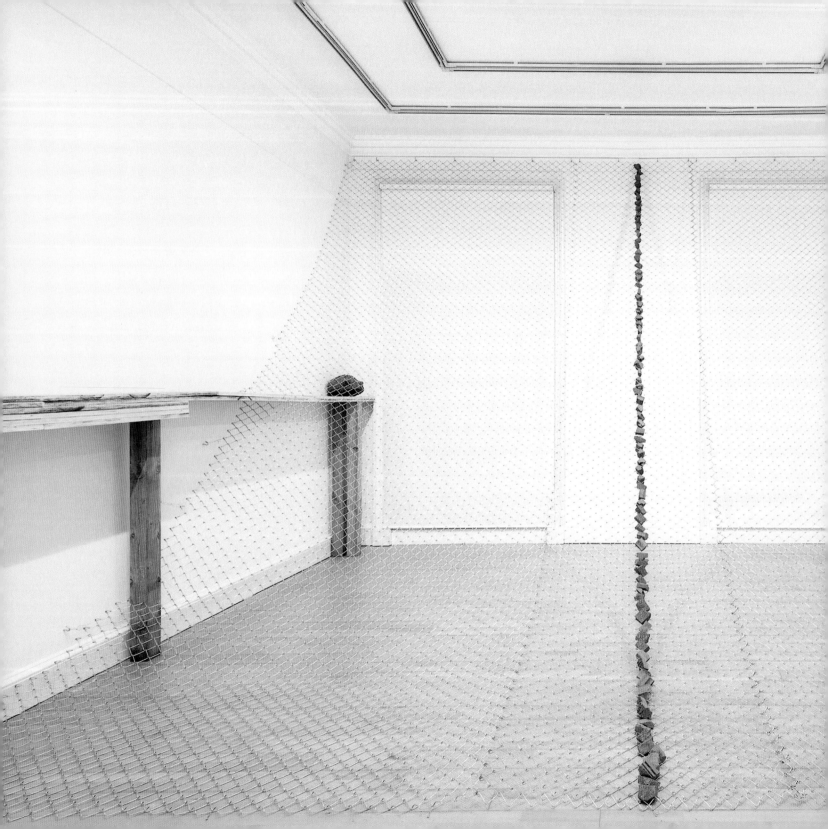

Kishio Suga **Condition of a Critical Boundary**, 1972 / 2016
臨界状況 (Rinkai Jōkyō), 1972 / 2016

Kishio Suga **Interconnected Spaces**, 2016
空連化 (Kūrenka), 2016

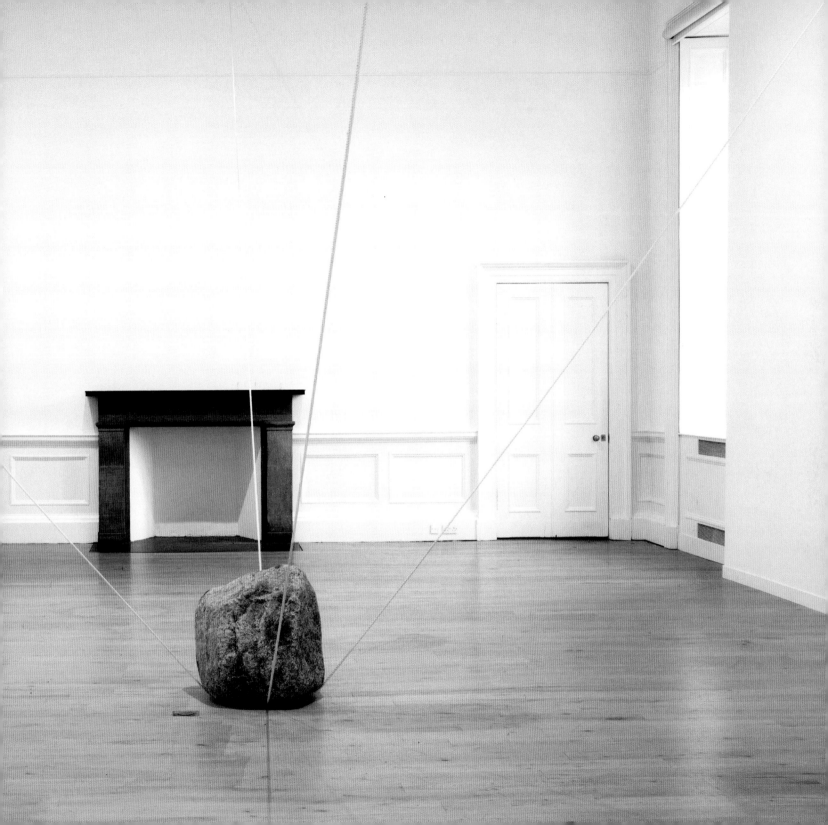

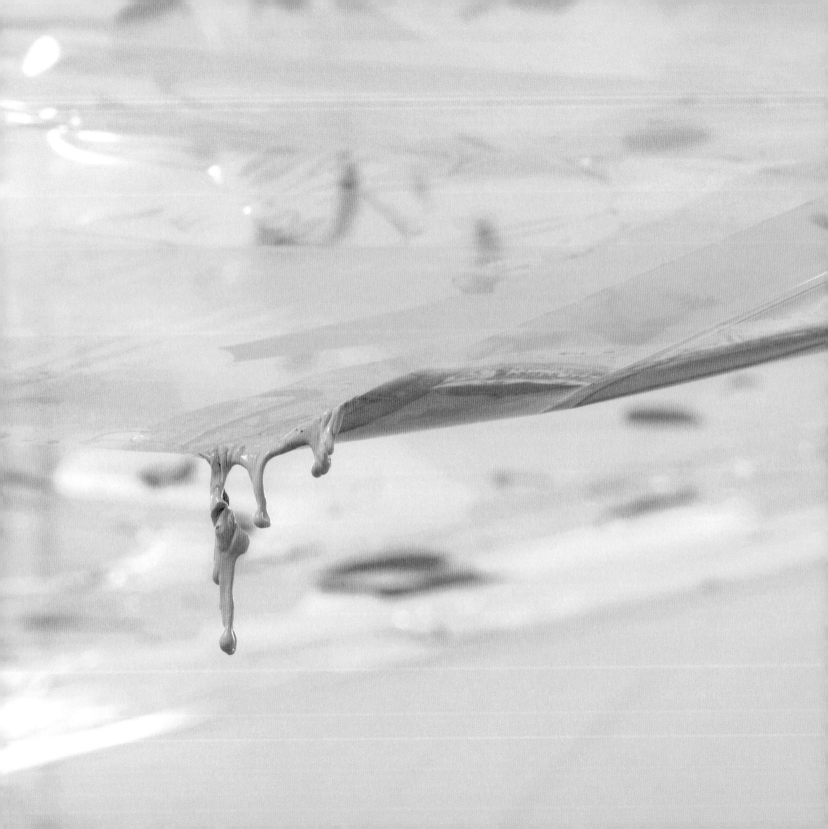

INTERVIEW WITH KARLA BLACK

For those who may be unfamiliar with your work, can you tell us a little about what you do?

I make abstract sculpture. There is no figure, no representation of anything in it – and that's very deliberate. Because traditionally representation links to the symbol and the metaphor in language, at least in the art of the Western world in recent times, and that's something I'm trying to get away from. In terms of communication, I feel that language is quite an inadequate, primitive tool when you compare it to free colour, form and materials. I suppose what I'm trying to do is to have a much more direct relationship with the material, physical world. When you're a really young child, and you start to make marks, they're abstract. Obviously you move through that to representation at a certain point; and then, like I did at art school, you can move away from it again. The way children work when they first draw or just play around with materials is closer to what I'm doing now.

Could you expand upon your interest in childhood play and early learning?

I've always been fascinated by that stage of early childhood play where babies and toddlers work with materials on the floor. The theoretical base of the work is quite psychoanalytic but not Freudian, it's more Kleinian. Melanie Klein was a student of Freud and she moved psychoanalysis on to work with babies and small children, who are pre-speech. She was able to find meaning, or analyse their behaviour, within the physical world and the way they move in relation to materials or objects in a room.

I always think about how, when a baby is born, the first experience of the physical, material world is the mother's body. Then that moves quickly to the floor. Often the first thing you see a child play with is milk – some comes out of a bottle and they immediately start to make marks within that substance. It's very abstract, behavioural and free in terms of mark making. I will never get back to that. I try, but I don't think you can suspend your conscious mind to that extent.

I look a lot at the first artworks that were created by humans in caves, and even before cave art, that are just markings on stones. For example, there are caves in the South of Australia that have within them a calcium-based material, called moonmilk, that doesn't ever harden like plaster or rock, because of the damp conditions. At an early stage of human development, people ran their hands down it, made hand prints, made marks, and they are all still there something like 20,000 years later. They're still wet – they've never dried. You could touch them. In terms of touching the world, I don't see art as being about much more than that. I don't feel that this takes its power away or makes it less meaningful or less communicative. A painting is traditionally a window onto another world. Painting is a sort of optical, cerebral escape. Sculpture is the opposite of that. It grounds you in material reality. It is an absorption, it roots you here in the world. I can feel that way outside in the landscape or looking at a sculpture.

Karla Black
[top row] **Won't Know; Wouldn't Know; Wouldn't Want**
[bottom row] **Invite Often; Couldn't Know; Couldn't Want**
All 2016

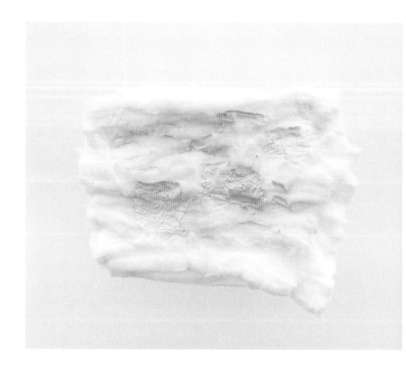

Can you talk about some of the materials you use, including those used in the exhibition, and what it is that draws you to them?

I love powders, pastes, oils, creams and gels. And I like to preserve their rawness. For example, traditionally, within the history of making sculpture, a powdered substance like plaster would be mixed up. It would go through a chemical process. It would become a harder permanent form and structure. But I prefer to use it just as powder. In a way, I like to try to retard the potential within the material: to not let it lose that life that it can have at a certain point. There is some plaster powder in this show, but it's a very small amount – I've used a lot more at other times.

The bulk of the material in this show is cotton wool, and then there's a lot of paint. Often people look at my sculptures and see the unconventional materials, but usually that's a really small amount of the work. I use very traditional art materials in the main: lots of plaster and lots of paint – whether that's powder paint or acrylic. In this show I have used paper, cellophane, cotton wool, eyeshadow and polythene.

When making a sculpture, I stop quite near the beginning of the process with materials; to try to have paint that won't dry or plaster that won't set. I've always felt that once the paint is dry, or once the plaster is set, then the work is a bit dead. Especially for other people, for people looking at it: like there was no room left for them to enter into it, even just in a cerebral way.

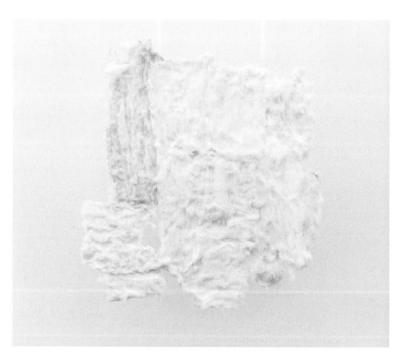

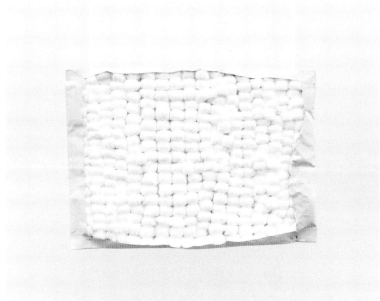

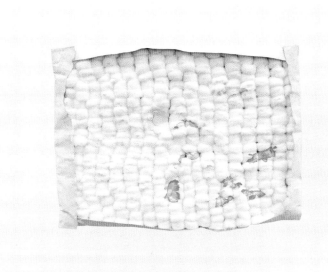

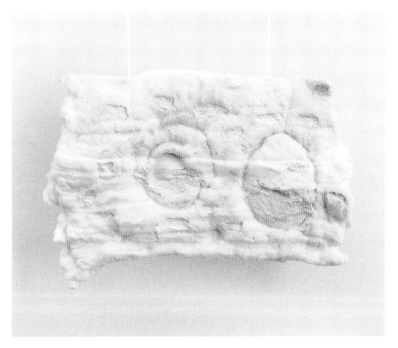

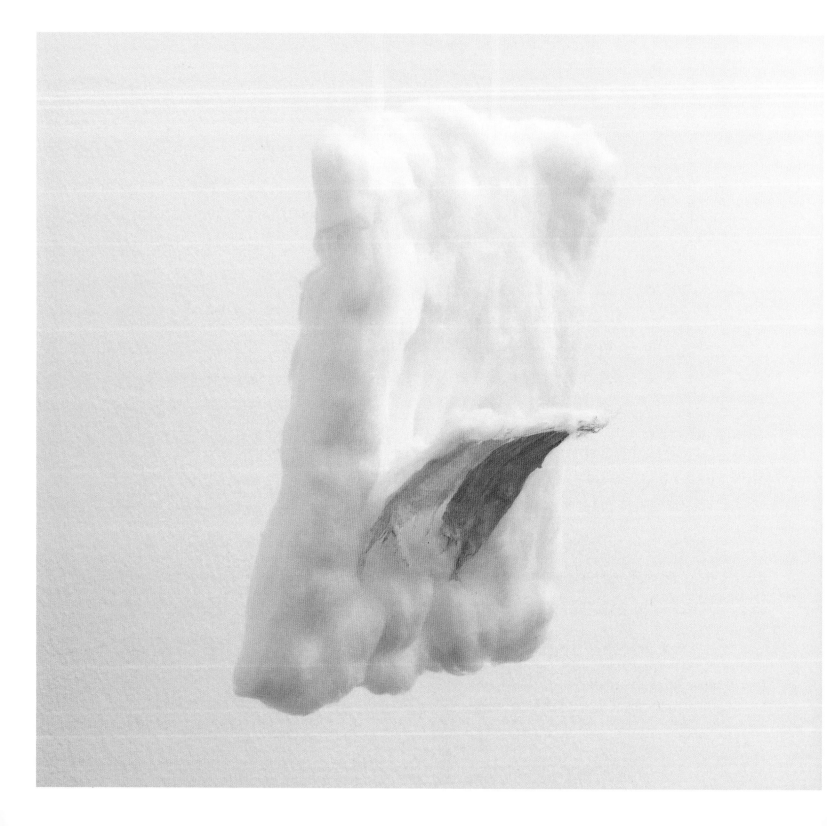

Materials, objects and colours have inherent connotations, but you've said previously that you don't choose materials for what they might traditionally be associated with. Could you speak a bit about that?

Obviously, what other people bring to the work when they look at it is something else. It's not important to me to try to control a view of the work or any thoughts about it. But I suppose it is important for me to at least say what my intentions are. When I'm working with a colour or a material, I'm doing it purely out of a desire for that colour or that material. I don't differentiate between materials. I don't see a hierarchy. I'm not interested in the cultural connotations. For me, whatever is within my own material experience, I can use. It's a totally abstract, unconscious, physical thing.

If you look at what my materials are made up of, you see that they're not actually very different from each other. If you discount the cultural connotations that relate to something like eyeshadow and you break down its chemical properties, it's pretty much the same as chalk or plaster powder or artists' pigment. When you think about what an art material is, it's pretty ridiculous to say that certain things are conventional materials because some factory mixed them up and they are sold in a shop with a label on them. There is not much difference between the chemist and the art store, just how materials are labelled in a capitalist society. You can put anything on your body and you can smear anything you want into a bit of paper; it just depends who's the boss of that. What I look at all the time is the different qualities of these powdered substances and how a certain kind of paper, or balsa wood, or polythene, will take

them. Powdered pigment isn't 'better' to use than eyeshadow. Eyeshadow has a specific kind of texture, because it's made to be applied to skin. It's softer, it's easier to use, and it goes further. Some really velvety eyeshadows will work much better into paper than artists' pigment would. Because with powdered artists' pigment, the purpose is to mix it up and make paint: it doesn't work very well when you try to rub it into paper or wood. Also, in terms of my taste and the colours that I use, I can get much better pre-mixed colours in eyeshadow ranges than I can in artists' pigment. I mix my own paints. I can mix whatever colour I want, but I look for these very light colours. If you buy powdered artists' pigment from an art shop, it's usually pretty dark because it's made to be mixed up into paint. But I like to get as close to white as I can; much of my work, formally and in terms of colour, is just 'almost' or 'nearly'.

Many of the materials you use have a limited lifespan. Do you consider the future of your works as part of the making process?

In terms of making artwork, it's all too easy to paralyse yourself with pressure at the beginning of a process, when you have specific expectations or outcomes in mind. I think it's difficult enough anyway, so I give myself the permission at that point to do what I want. That's how I choose materials. Then I start to work with them, and then quite quickly the conscious mind comes into play. It's something like an editing process – a sort of attempt at structure, perhaps. This is purely because when you're working with materials in this way, and making abstract artwork, there's the

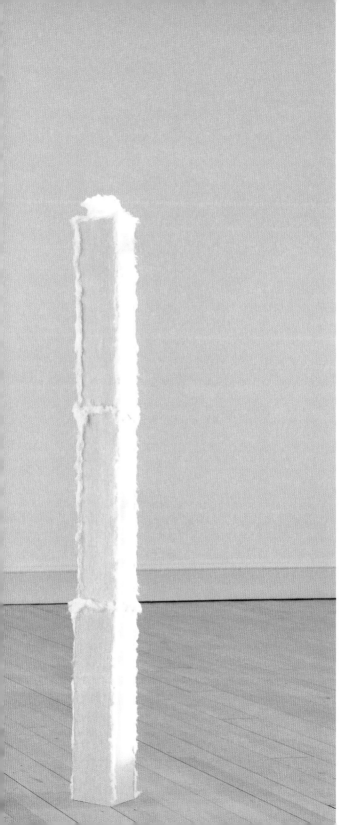

Karla Black **Actually Mark**, 2016

potential for it to be purely gestural; and there's nothing wrong with that, but that's not what I do. I feel like it could be far too self-indulgent.

Another way to paralyse the creative process is by worrying at the beginning about whether it is going to last for ten years? For 500 years? I try to put these things aside and worry about them later on instead. First, I just get in amongst the materials and do what I think should be done with them. People generally assume that what I'm doing is a choice, but that's not necessarily the case, because choices are limited, especially when making sculpture or any sort of artwork. Like anyone else, I'm working within the limits of the physical world – even just things like the force of gravity. There are going to be things that I want to do but can't. What I want is the life and the energy within the materials to be there. To be felt, or communicated, or however you might describe that. Also I have a real desire for permanence, because I care so much about the aesthetics. What's really important to me in my work is the relationship between composition, form, colour and material, and getting that right. When I make what I think is a good piece of work, I want nothing more than for it to stay like that forever. When it's finished, it's finished. Obviously the materials that I use compromise this. At one point I thought to myself: 'If you want it to stay like that, you know what to do: use stone, wood, metal.' But I just feel that those materials are too static. The life, the energy, isn't there. The work doesn't have the movement that I want, or the openness to other people. So I made a choice not to use those things. That's not to say that I don't want permanence, because I do.

Your work takes a range of forms, but you are resolute in your desire for it to be talked of as sculpture. Can you go into a little more detail about this?

It's very important to me that what I make is sculpture. It was in the '50s, '60s and '70s that sculpture broke itself apart into all the new forms of Post-Modernism. Things like performance art, land art, sound art and even video art – they all came out of sculpture. They are all art forms that involve space and time, and some sort of relationship to mass and to form. That development was so free and experimental, especially where materials are concerned. What I love about Modernism, about the autonomous sculptural object, about painting, in the abstract moment of high Modernism (Sonia Delaunay or František Kupka), is how careful those aesthetics are, the relationship between composition, form, material and colour. I feel that all the experimentation of the '60s and '70s had to happen at that moment, to free everything up. But what then got lost were the aesthetics. So in a way what I'm trying to do is still to be within that moment of experimentation in sculpture, while at the same time pulling it back a bit – back towards Modernism, back towards autonomy and a time when artists were very careful about aesthetics. When people are looking at my work, they often ask why I say that these things are sculptures, when they seem so close to other mediums. They are often nearly paintings, or performance art, or installations – but I try to get as far as I can towards those other mediums and then just pull it back at the last minute to say that this can still be a sculpture. The works in the corridor in the show obviously look a lot like paintings,

but they are hung out from the wall [see pp.24–26]. They have just enough form. They're very thin: I like to see how thin I can go with an artwork and still say it's a sculpture and not a painting. The same with works in the show that are nearly installations. They're made on site, they rely on the architecture around them, they can't really exist without it or in any other situation, but they still have edges. They're still separate enough from the other works that I can say that they're individual sculptures. The reason why I want to do that is because autonomous sculpture can hold its aesthetics within it, and doesn't collapse into pure gesture, pure experimentation, which doesn't interest me so much.

Going back, can you describe the beginnings of your work?

It's hard for me to think back to how I started – to what my headspace was and what my intentions were when I graduated from art school [Black graduated from the sculpture department of the BA (Hons) Fine Art course at the Glasgow School of Art in 1999]. I never go back to the beginning; I'm always working from whatever the last thing was that I did. I do know that I've always loved materials and colour, and that remains. I've also always loved the landscape, and being outside, in the same way as I love any kind of art-making material. I've used earth, plaster, clay – they all come out of the ground. They're not 'different'; they're the material world. A lot of what I do, I think of as scrabbling about in the dirt. What art does as a category is to put a fence around something that is actually a natural, human, animal behaviour and make it a respectable activity to engage in within civilised society. At some point

Karla Black **Of End**, 2016

the conscious mind then intervenes through the 'editing' process, and language comes in towards the end. With my work, I'm trying to elicit at least an impetus towards a physical response. It's hard to express in words what the work is about or what it's trying to achieve, because in reality it's a visceral thing. There is a physical response to be had when you're looking at it, and that comes from the openness and the rawness of the materials and colour.

Transcribed and edited from an interview with Becky Manson, Digital Content Curator at the National Galleries of Scotland, filmed in October 2016 to coincide with the exhibition. Available to view at www.nationalgalleries.org

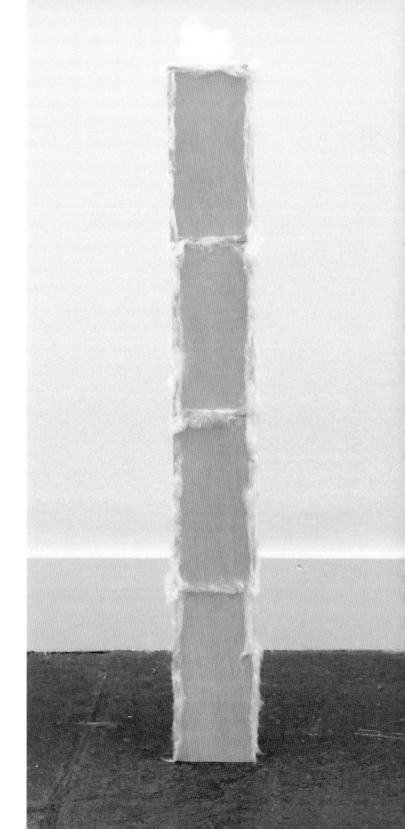

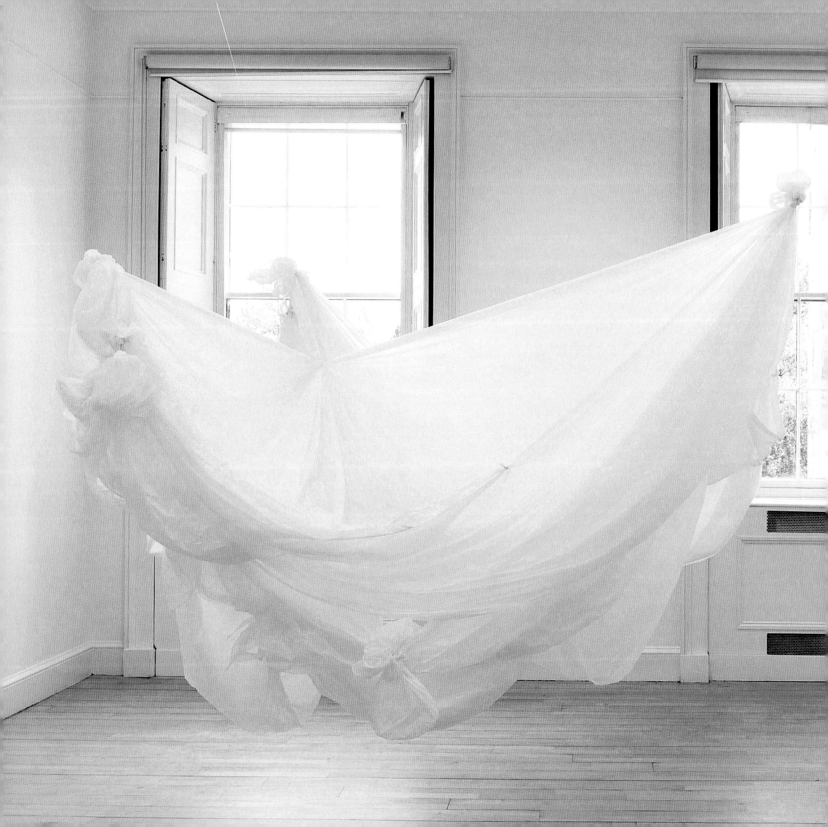

Karla Black **Other Civil Words**, 2016
[installation view; detail]

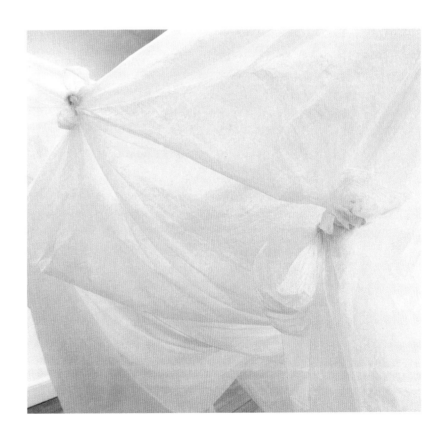

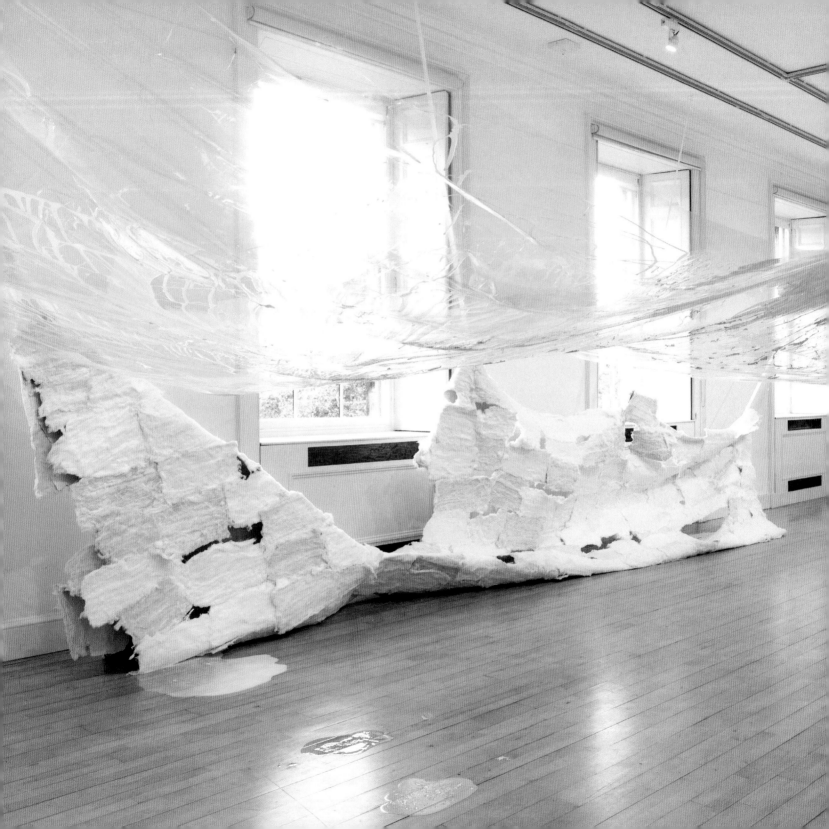

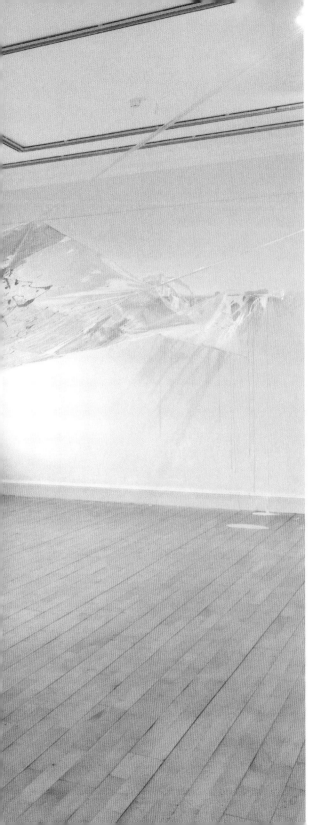

[above] Karla Black **Recognises**, 2016

[below] Karla Black **Can't Regard**, 2016

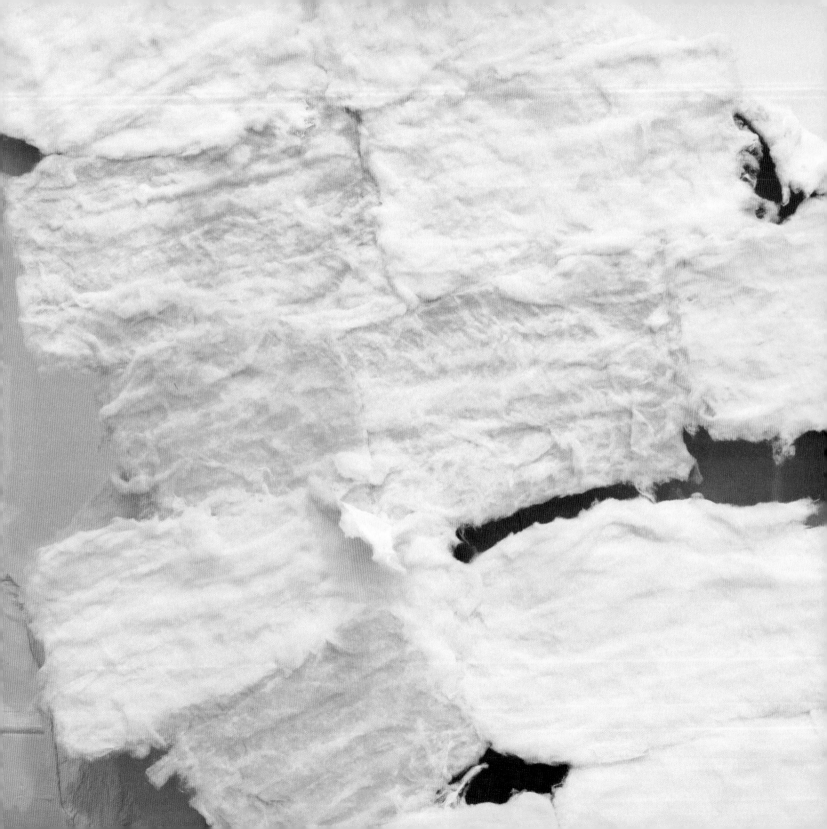

Karla Black **Can't Regard**, 2016 [detail]

Karla Black **Recognises**, 2016 [detail]

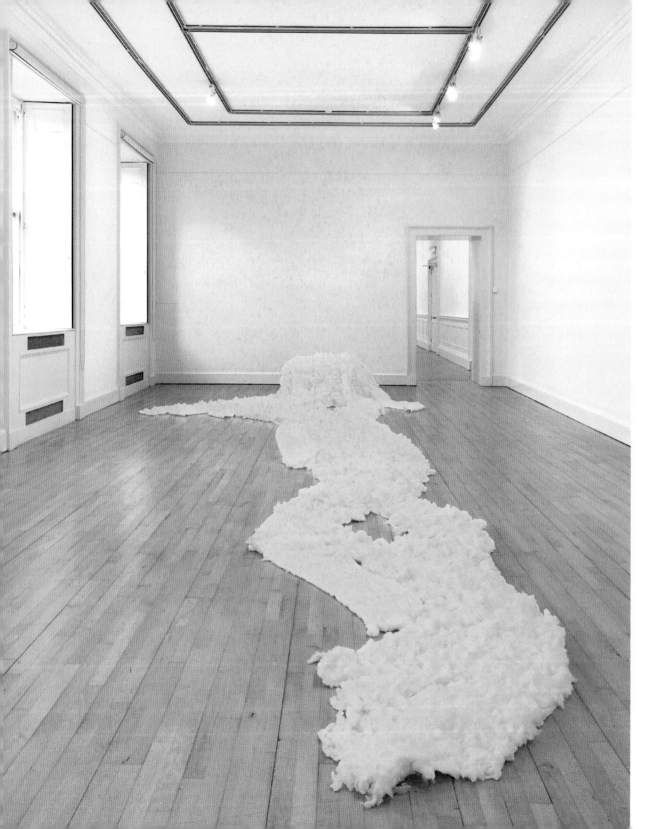

Karla Black

Better In Form, 2016

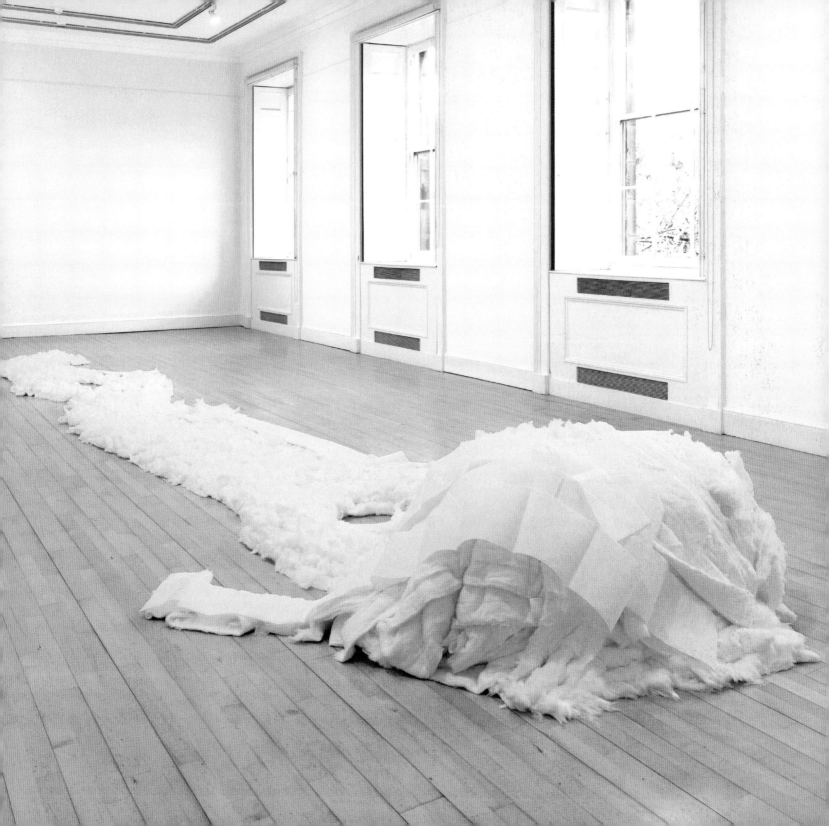

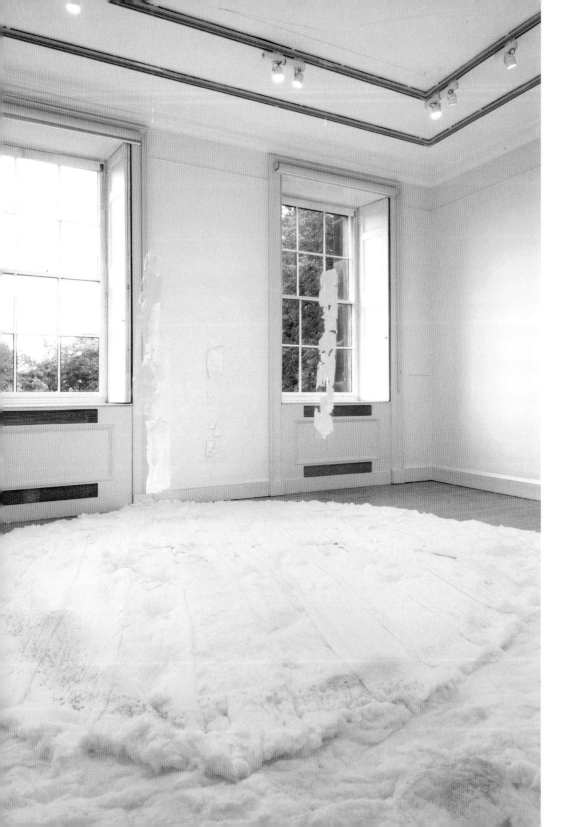

Karla Black **Too Much About Home**, 2016
[installation view; detail]

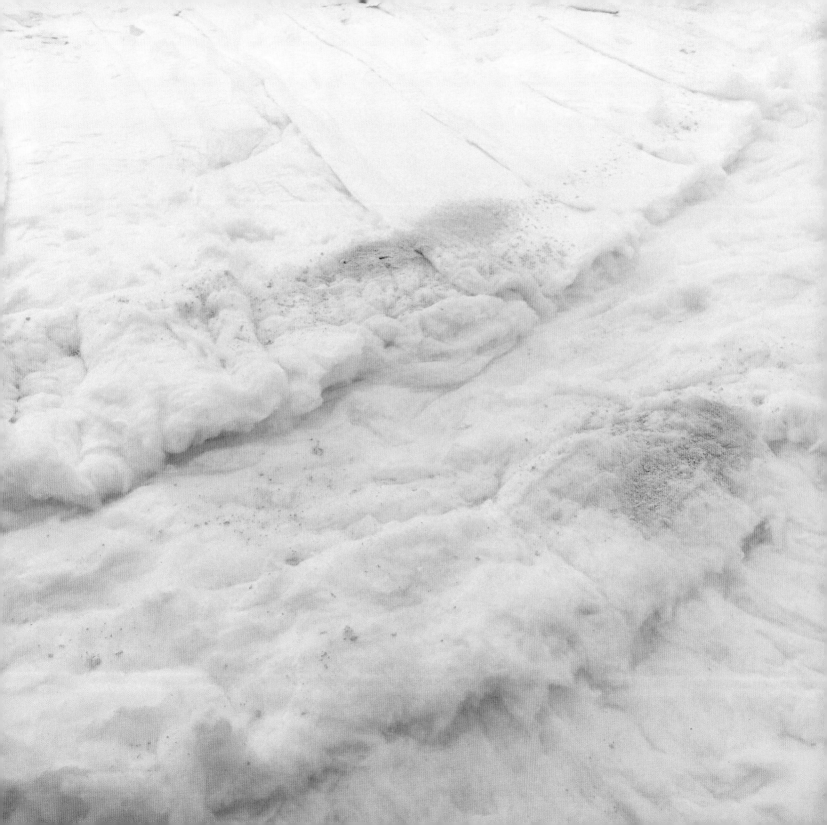

KISHIO SUGA 菅木志雄

b.1944, Morioka, Iwate Prefecture, Japan

Kishio Suga's career began at a time of great artistic and political upheaval in Japan in the late 1960s, and after graduating he quickly became an important figure within the *Mono-ha* movement. Although the Japanese term *Mono-ha* literally translates as 'School of Things', the artists were neither an organised group, nor were their individual practices exclusively focused on 'things' or objects. Their diverse work was united by the decision to use simple materials – both natural and industrially manufactured – as a means to explore the relationships between the individual, matter and surrounding space. Their works were often the result of direct, interactive actions with the materials they employed, such as suspending, dropping, breaking and stacking.

Through his installations, photographs and performances Suga actively rejects the idea of the artist as a creator of the new, and instead aims to present us with the world as it is. A crucial aspect of his works is that they are open to reinvention and can adapt to the spaces and contexts in which they are displayed.

Suga studied oil painting at the Tama Art University, graduating in 1968. Solo exhibitions of his work have been staged at the Pirelli HangarBicocca, Milan (2016), the Dia: Chelsea, New York (2016) and the Museum of Contemporary Art, Tokyo (2015). He lives and works in Itō, Shizuoka, Japan.

KARLA BLACK

b.1972, Alexandria, Scotland

Karla Black's sculptures explore material and physical experience as a way of communicating and understanding the world around us. This approach is rooted in her interest in ideas of play and early childhood learning. In the past, Black's works have been described as falling between various categories; they can be seen as 'almost' performance or 'almost' painting, but despite this affinity with other mediums, the artist is resolute that they are sculptures.

Her works take a range of forms, from cellophane, paper, cotton wool, and polythene hanging pieces suspended with ribbon or tape, to large-scale, floor-based works made from plaster, chalk powder and soil. Black selects her materials based on the texture, weight and feel of a substance rather than its wider associations, and similarly the artist has no interest in any connotations that might be made between gender and colour.

Black studied Sculpture at the Glasgow School of Art, graduating in 1999. She gained an M Phil in Art in Organisational Contexts (1999–2000), and her Masters in Fine Art (2004) from the same place. Solo exhibitions of her work have been staged at the Institute of Contemporary Art, Philadelphia (2013), the Gallery of Modern Art, Glasgow (2012), and the Migros Museum, Zurich (2009), among others. She represented Scotland at the Venice Biennale in 2011 and currently lives and works in Glasgow.

LIST OF WORKS KARLA BLACK

Careful Response, 2016
Cotton wool, paint, ribbon, paper
26 x 23 x 4 cm

Wouldn't Want, 2016
Cotton wool, sugar paper, paint, ribbon
45 x 60 x 4 cm

Couldn't Know, 2016
Cotton wool, sugar paper, paint, ribbon
46 x 60 x 6 cm

Couldn't Want, 2016
Cotton wool, sugar paper, paint, ribbon
73 x 110 x 10 cm

Wouldn't Know, 2016
Cotton wool, sugar paper, paint, ribbon
45 x 65 x 4 cm

Won't Know, 2016
Cotton wool, sugar paper, paint, ribbon
57 x 85 x 10 cm

Invite Often, 2016
Cotton wool, paint, ribbon
73 x 63 x 4 cm

Of End, 2016
Cotton wool, balsa wood, eyeshadow
110 x 15 x 15 cm

Too Much About Home, 2016
Cotton wool, powder paint, plaster powder, cellophane,
paint, sellotape
110 x 480 x 480 cm

Actually Mark, 2016
Cotton wool, balsa wood, eyeshadow
146 x 15 x 15 cm

Better In Form, 2016
Cotton wool, kitchen towel
100 x 400 x 1100 cm

Recognises, 2016
Cellophane, sellotape, PVA glue, paint
150 x 1310 x 450 cm

Can't Regard, 2016
Cotton wool, paint, ribbon, paper
180 x 1000 x 10 cm

Other Civil Words, 2016
Polythene, powder paint, plaster powder, thread
180 x 200 x 200 cm

KISHIO SUGA 菅木志雄

Determined Condition, **Discrepant Placement**,
1969 / 2016
定状差置 (Teijō Sachi), 1969 / 2016
Plywood 合板, Stone 石
1470 × 122.5 × 40 cm

Infinite Situation III (Door), 1970 / 2016
無限状況 III (扉) (Mugen Jōkyō III (tobira)), 1970 / 2016
Wood 木, door frame 戸枠, Landscape 風景
290 × 15.2 × 15.2 cm

Edges of Gathered Realms, 1993 / 2016
端の集界 (Tan no Shūkai), 1993 / 2016
Stone 石, Zinc sheet 亜鉛板
28.5 × 530 × 209.5 cm

Infinite Situation I (Window), 1970 / 2016
無限状況 I (窓) (Mugen Jōkyō I (mado)), 1970 / 2016
Wood 木, window frame 窓枠, Landscape 風景
160.6 × 9.5 × 9.5 cm (left, from outside);
151 × 9.5 × 9.5 cm (right, from outside)

Left-Behind Situation, 1972 / 2016
捨置状況 (Shachi Jōkyō), 1972 / 2016
Wood 木, Stone 石, Steel plate 鉄, Brick レンガ, Wire rope
ワイヤーロープ
183 × 919 × 592 cm
Courtesy of the Glenstone Foundation,
Potomac, Maryland, USA

Condition of a Critical Boundary, 1972 / 2016
臨界状況 (Rinkai Jōkyō), 1972 / 2016
Wood 木, Stone 石, Wire mesh 鉄網, Brick レンガ
415 × 601 × 605 cm

Interconnected Spaces, 2016
空連化 (Kūrenka), 2016
Rock 石, Rope ロープ
600 × 1632 × 919 cm

Appearance in Phase, 1969
表間相 (Hyōkansō), 1969
C-print
36.2 × 44.1 cm

Inactive Environment, 1970
無為状況 (Mui Jōkyō), 1970
C-print
36.2 × 44.1 cm

Branched Condition, 1973
枝況 (Shikyō), 1973
C-print
36.2 × 44.1 cm

Connection, 1973
弦 (Gen), 1973
C-print
36.2 × 44.1 cm

Floating Units of Perception, 1973

水上識体 (Suijō Shikitai), 1973
C-print
36.2 × 44.1 cm

Elemental Realm, 1974

素界 (Sokai), 1974
C-print
36.2 × 44.1 cm

Remaining Locating, 1975

留位地 (Ryūichi), 1975
C-print
36.2 × 44.1 cm

Remaining Space, 1975

間留 (Kanryū), 1975
C-print
36.2 × 44.1 cm

Natural Order, 1975

自然律 (Shizenritsu), 1975
C-print
36.2 × 44.1 cm

Appearing Space, 1982

表空 (Hyōkū), 1982
C-print
36.2 × 44.1 cm

Condition of Perception, 1970

識況 (Shikikyō), 1970
Silver gelatin print
90 × 64 cm

Located Situation, 1970

況位 (Kyōi), 1970
Silver gelatin print
90 × 64 cm

Space-Order, 1974

界律 (Kairitsu), 1974
Silver gelatin print
Five parts, each 53 × 36 cm

Fieldology, 1974

Event at Gallery 16, Kyoto, 1974
Digital video
Running time: 23 minutes 59 seconds

For the Side Corners, 1976

Event at Kyoto Municipal Museum of Art, Kyoto, 1976
Digital video
Running time: 19 minutes 17 seconds

KARLA BLACK
All works courtesy of the artist and Galerie Gisela
Capitain, Cologne; Modern Art, London; and David Zwirner,
New York / London

KISHIO SUGA
All works courtesy of the artist and Blum & Poe,
Los Angeles / New York / Tokyo; except *Left-Behind Situation*:
Courtesy of the Glenstone Foundation, Potomac, Maryland,
USA; illustrations of photographic works courtesy Tomio
Koyama Gallery, Tokyo

All other photography by Sam Drake and Jessie
Maucor; © National Galleries of Scotland

'Between "Presence" and "Nothingness"' © Kishio Suga 2005

Published by the Trustees of the National Galleries of Scotland
to accompany the exhibition *Karla Black and Kishio Suga: A New
Order*, held at the Scottish National Gallery of Modern Art,
Edinburgh from 22 October 2016 to 19 February 2017

© The Trustees of the National Galleries of Scotland, 2017

ISBN 978 1 911054 08 5

Designed and typeset in MVB Sweet Sans Pro by Dalrymple
Printed in Belgium on Symbol Tatami by Albe De Coker

Jacket design: O Street

This exhibition has been assisted by the Scottish Government
and the Government Indemnity Scheme.

This catalogue has been supported by a grant from the
Japan Foundation.

The proceeds from the sale of this book go towards supporting
the National Galleries of Scotland. For a complete list of current
publications, please write to: NGS Publishing at the Scottish
National Gallery of Modern Art, 75 Belford Road, Edinburgh
EH4 3DR or visit our website: www.nationalgalleries.org

National Galleries of Scotland is a charity registered in
Scotland (No.SC003728)